THIS LOG BELONGS TO

ADDRESS

EMAIL

PHONE

CONTENTS

CLIENT NAME / REFERENCE NUMBER	PAGE

CONTENTS

CLIENT NAME / REFERENCE NUMBER	PAGE

CONTENTS

CLIENT NAME / REFERENCE NUMBER	PAGE

CONTENTS

CLIENT NAME / REFERENCE NUMBER	PAGE

CLIENT NAME

DATE

PHONE

EMAIL

LOOK / OCCASION

SKIN

PRIMER

FOUNDATION

CONCEALER

POWDER

HIGHLIGHTER

CONTOUR

BLUSH

EYES

BROW BONE

LID

CREASE

UNDER EYE

EYELINER

MASCARA

BROW

LIPS

LIP LINER

LIPSTICK

GLOSS

KEY PRODUCTS AND TOOLS

NOTES / INSPIRATION

CLIENT NAME

DATE

PHONE
EMAIL
LOOK / OCCASION

SKIN

PRIMER

FOUNDATION

CONCEALER

POWDER

HIGHLIGHTER

CONTOUR

BLUSH

EYES

BROW BONE

LID

CREASE

UNDER EYE

EYELINER

MASCARA

BROW

LIPS

LIP LINER

LIPSTICK

GLOSS

NOTES / INSPIRATION

KEY PRODUCTS AND TOOLS

CLIENT NAME

DATE

PHONE
EMAIL
LOOK / OCCASION

SKIN

PRIMER

FOUNDATION

CONCEALER

POWDER

HIGHLIGHTER

CONTOUR

BLUSH

EYES

BROW BONE

LID

CREASE

UNDER EYE

EYELINER

MASCARA

BROW

LIPS

LIP LINER

LIPSTICK

GLOSS

KEY PRODUCTS AND TOOLS

NOTES / INSPIRATION

CLIENT NAME

DATE

PHONE

EMAIL

LOOK / OCCASION

SKIN

PRIMER

FOUNDATION

CONCEALER

POWDER

HIGHLIGHTER

CONTOUR

BLUSH

EYES

BROW BONE

LID

CREASE

UNDER EYE

EYELINER

MASCARA

BROW

LIPS

LIP LINER

LIPSTICK

GLOSS

KEY PRODUCTS AND TOOLS

NOTES / INSPIRATION

CLIENT NAME

DATE

PHONE
EMAIL
LOOK / OCCASION

SKIN

PRIMER

FOUNDATION

CONCEALER

POWDER

HIGHLIGHTER

CONTOUR

BLUSH

EYES

BROW BONE

LID

CREASE

UNDER EYE

EYELINER

MASCARA

BROW

LIPS

LIP LINER

LIPSTICK

GLOSS

NOTES / INSPIRATION

KEY PRODUCTS AND TOOLS

CLIENT NAME

DATE

PHONE
EMAIL
LOOK / OCCASION

SKIN

PRIMER

FOUNDATION

CONCEALER

POWDER

HIGHLIGHTER

CONTOUR

BLUSH

EYES

BROW BONE

LID

CREASE

UNDER EYE

EYELINER

MASCARA

BROW

LIPS

LIP LINER

LIPSTICK

GLOSS

KEY PRODUCTS AND TOOLS

NOTES / INSPIRATION

CLIENT NAME

DATE

PHONE

EMAIL

LOOK / OCCASION

SKIN

PRIMER

FOUNDATION

CONCEALER

POWDER

HIGHLIGHTER

CONTOUR

BLUSH

EYES

BROW BONE

LID

CREASE

UNDER EYE

EYELINER

MASCARA

BROW

LIPS

LIP LINER

LIPSTICK

GLOSS

NOTES / INSPIRATION

KEY PRODUCTS AND TOOLS

CLIENT NAME

DATE

PHONE

EMAIL

LOOK / OCCASION

SKIN

PRIMER

FOUNDATION

CONCEALER

POWDER

HIGHLIGHTER

CONTOUR

BLUSH

EYES

BROW BONE

LID

CREASE

UNDER EYE

EYELINER

MASCARA

BROW

LIPS

LIP LINER

LIPSTICK

GLOSS

KEY PRODUCTS AND TOOLS

NOTES / INSPIRATION

CLIENT NAME

DATE

PHONE

EMAIL

LOOK / OCCASION

SKIN

PRIMER

FOUNDATION

CONCEALER

POWDER

HIGHLIGHTER

CONTOUR

BLUSH

EYES

BROW BONE

LID

CREASE

UNDER EYE

EYELINER

MASCARA

BROW

LIPS

LIP LINER

LIPSTICK

GLOSS

KEY PRODUCTS AND TOOLS

NOTES / INSPIRATION

CLIENT NAME

DATE

PHONE

EMAIL

LOOK / OCCASION

SKIN

PRIMER

FOUNDATION

CONCEALER

POWDER

HIGHLIGHTER

CONTOUR

BLUSH

EYES

BROW BONE

LID

CREASE

UNDER EYE

EYELINER

MASCARA

BROW

LIPS

LIP LINER

LIPSTICK

GLOSS

KEY PRODUCTS AND TOOLS

NOTES / INSPIRATION

CLIENT NAME

DATE

PHONE
EMAIL
LOOK / OCCASION

SKIN

PRIMER

FOUNDATION

CONCEALER

POWDER

HIGHLIGHTER

CONTOUR

BLUSH

EYES

BROW BONE

LID

CREASE

UNDER EYE

EYELINER

MASCARA

BROW

LIPS

LIP LINER

LIPSTICK

GLOSS

KEY PRODUCTS AND TOOLS

NOTES / INSPIRATION

CLIENT NAME

DATE

PHONE

EMAIL

LOOK / OCCASION

SKIN

PRIMER

FOUNDATION

CONCEALER

POWDER

HIGHLIGHTER

CONTOUR

BLUSH

EYES

BROW BONE

LID

CREASE

UNDER EYE

EYELINER

MASCARA

BROW

LIPS

LIP LINER

LIPSTICK

GLOSS

KEY PRODUCTS AND TOOLS

NOTES / INSPIRATION

CLIENT NAME

DATE

PHONE

EMAIL

LOOK / OCCASION

SKIN

PRIMER

FOUNDATION

CONCEALER

POWDER

HIGHLIGHTER

CONTOUR

BLUSH

EYES

BROW BONE

LID

CREASE

UNDER EYE

EYELINER

MASCARA

BROW

LIPS

LIP LINER

LIPSTICK

GLOSS

KEY PRODUCTS AND TOOLS

NOTES / INSPIRATION

CLIENT NAME

DATE

PHONE
EMAIL
LOOK / OCCASION

SKIN

PRIMER
FOUNDATION
CONCEALER
POWDER
HIGHLIGHTER
CONTOUR
BLUSH

EYES

BROW BONE
LID
CREASE
UNDER EYE
EYELINER
MASCARA
BROW

LIPS

LIP LINER
LIPSTICK
GLOSS

KEY PRODUCTS AND TOOLS

NOTES / INSPIRATION

CLIENT NAME

DATE

PHONE

EMAIL

LOOK / OCCASION

SKIN

PRIMER

FOUNDATION

CONCEALER

POWDER

HIGHLIGHTER

CONTOUR

BLUSH

EYES

BROW BONE

LID

CREASE

UNDER EYE

EYELINER

MASCARA

BROW

LIPS

LIP LINER

LIPSTICK

GLOSS

KEY PRODUCTS AND TOOLS

NOTES / INSPIRATION

CLIENT NAME

DATE

PHONE

EMAIL

LOOK / OCCASION

SKIN

PRIMER

FOUNDATION

CONCEALER

POWDER

HIGHLIGHTER

CONTOUR

BLUSH

EYES

BROW BONE

LID

CREASE

UNDER EYE

EYELINER

MASCARA

BROW

LIPS

LIP LINER

LIPSTICK

GLOSS

KEY PRODUCTS AND TOOLS

NOTES / INSPIRATION

CLIENT NAME

DATE

PHONE
EMAIL
LOOK / OCCASION

SKIN

PRIMER

FOUNDATION

CONCEALER

POWDER

HIGHLIGHTER

CONTOUR

BLUSH

EYES

BROW BONE

LID

CREASE

UNDER EYE

EYELINER

MASCARA

BROW

LIPS

LIP LINER

LIPSTICK

GLOSS

KEY PRODUCTS AND TOOLS

NOTES / INSPIRATION

CLIENT NAME

DATE

PHONE

EMAIL

LOOK / OCCASION

SKIN

- PRIMER
- FOUNDATION
- CONCEALER
- POWDER
- HIGHLIGHTER
- CONTOUR
- BLUSH

EYES

- BROW BONE
- LID
- CREASE
- UNDER EYE
- EYELINER
- MASCARA
- BROW

LIPS

- LIP LINER
- LIPSTICK
- GLOSS

KEY PRODUCTS AND TOOLS

NOTES / INSPIRATION

CLIENT NAME

DATE

PHONE

EMAIL

LOOK / OCCASION

SKIN

PRIMER

FOUNDATION

CONCEALER

POWDER

HIGHLIGHTER

CONTOUR

BLUSH

EYES

BROW BONE

LID

CREASE

UNDER EYE

EYELINER

MASCARA

BROW

LIPS

LIP LINER

LIPSTICK

GLOSS

KEY PRODUCTS AND TOOLS

NOTES / INSPIRATION

CLIENT NAME

DATE

PHONE

EMAIL

LOOK / OCCASION

SKIN

PRIMER

FOUNDATION

CONCEALER

POWDER

HIGHLIGHTER

CONTOUR

BLUSH

EYES

BROW BONE

LID

CREASE

UNDER EYE

EYELINER

MASCARA

BROW

LIPS

LIP LINER

LIPSTICK

GLOSS

KEY PRODUCTS AND TOOLS

NOTES / INSPIRATION

CLIENT NAME

DATE

PHONE
EMAIL
LOOK / OCCASION

SKIN

PRIMER

FOUNDATION

CONCEALER

POWDER

HIGHLIGHTER

CONTOUR

BLUSH

EYES

BROW BONE

LID

CREASE

UNDER EYE

EYELINER

MASCARA

BROW

LIPS

LIP LINER

LIPSTICK

GLOSS

KEY PRODUCTS AND TOOLS

NOTES / INSPIRATION

CLIENT NAME

DATE

PHONE

EMAIL

LOOK / OCCASION

SKIN

PRIMER

FOUNDATION

CONCEALER

POWDER

HIGHLIGHTER

CONTOUR

BLUSH

EYES

BROW BONE

LID

CREASE

UNDER EYE

EYELINER

MASCARA

BROW

LIPS

LIP LINER

LIPSTICK

GLOSS

KEY PRODUCTS AND TOOLS

NOTES / INSPIRATION

CLIENT NAME

DATE

PHONE

EMAIL

LOOK / OCCASION

SKIN

PRIMER

FOUNDATION

CONCEALER

POWDER

HIGHLIGHTER

CONTOUR

BLUSH

EYES

BROW BONE

LID

CREASE

UNDER EYE

EYELINER

MASCARA

BROW

LIPS

LIP LINER

LIPSTICK

GLOSS

KEY PRODUCTS AND TOOLS

NOTES / INSPIRATION

CLIENT NAME

DATE

PHONE

EMAIL

LOOK / OCCASION

SKIN

PRIMER

FOUNDATION

CONCEALER

POWDER

HIGHLIGHTER

CONTOUR

BLUSH

EYES

BROW BONE

LID

CREASE

UNDER EYE

EYELINER

MASCARA

BROW

LIPS

LIP LINER

LIPSTICK

GLOSS

KEY PRODUCTS AND TOOLS

NOTES / INSPIRATION

CLIENT NAME

DATE

PHONE
EMAIL
LOOK / OCCASION

SKIN

PRIMER

FOUNDATION

CONCEALER

POWDER

HIGHLIGHTER

CONTOUR

BLUSH

EYES

BROW BONE

LID

CREASE

UNDER EYE

EYELINER

MASCARA

BROW

LIPS

LIP LINER

LIPSTICK

GLOSS

KEY PRODUCTS AND TOOLS

NOTES / INSPIRATION

CLIENT NAME

DATE

PHONE

EMAIL

LOOK / OCCASION

SKIN

PRIMER

FOUNDATION

CONCEALER

POWDER

HIGHLIGHTER

CONTOUR

BLUSH

EYES

BROW BONE

LID

CREASE

UNDER EYE

EYELINER

MASCARA

BROW

LIPS

LIP LINER

LIPSTICK

GLOSS

KEY PRODUCTS AND TOOLS

NOTES / INSPIRATION

CLIENT NAME

DATE

PHONE

EMAIL

LOOK / OCCASION

SKIN

PRIMER

FOUNDATION

CONCEALER

POWDER

HIGHLIGHTER

CONTOUR

BLUSH

EYES

BROW BONE

LID

CREASE

UNDER EYE

EYELINER

MASCARA

BROW

LIPS

LIP LINER

LIPSTICK

GLOSS

KEY PRODUCTS AND TOOLS

NOTES / INSPIRATION

CLIENT NAME

DATE

PHONE

EMAIL

LOOK / OCCASION

SKIN

PRIMER

FOUNDATION

CONCEALER

POWDER

HIGHLIGHTER

CONTOUR

BLUSH

EYES

BROW BONE

LID

CREASE

UNDER EYE

EYELINER

MASCARA

BROW

LIPS

LIP LINER

LIPSTICK

GLOSS

KEY PRODUCTS AND TOOLS

NOTES / INSPIRATION

CLIENT NAME

DATE

PHONE

EMAIL

LOOK / OCCASION

SKIN

PRIMER

FOUNDATION

CONCEALER

POWDER

HIGHLIGHTER

CONTOUR

BLUSH

EYES

BROW BONE

LID

CREASE

UNDER EYE

EYELINER

MASCARA

BROW

LIPS

LIP LINER

LIPSTICK

GLOSS

KEY PRODUCTS AND TOOLS

NOTES / INSPIRATION

CLIENT NAME

DATE

PHONE

EMAIL

LOOK / OCCASION

SKIN

PRIMER

FOUNDATION

CONCEALER

POWDER

HIGHLIGHTER

CONTOUR

BLUSH

EYES

BROW BONE

LID

CREASE

UNDER EYE

EYELINER

MASCARA

BROW

LIPS

LIP LINER

LIPSTICK

GLOSS

KEY PRODUCTS AND TOOLS

NOTES / INSPIRATION

CLIENT NAME

DATE

PHONE

EMAIL

LOOK / OCCASION

SKIN

PRIMER

FOUNDATION

CONCEALER

POWDER

HIGHLIGHTER

CONTOUR

BLUSH

EYES

BROW BONE

LID

CREASE

UNDER EYE

EYELINER

MASCARA

BROW

LIPS

LIP LINER

LIPSTICK

GLOSS

KEY PRODUCTS AND TOOLS

NOTES / INSPIRATION

CLIENT NAME

DATE

PHONE

EMAIL

LOOK / OCCASION

SKIN

PRIMER

FOUNDATION

CONCEALER

POWDER

HIGHLIGHTER

CONTOUR

BLUSH

EYES

BROW BONE

LID

CREASE

UNDER EYE

EYELINER

MASCARA

BROW

LIPS

LIP LINER

LIPSTICK

GLOSS

KEY PRODUCTS AND TOOLS

NOTES / INSPIRATION

CLIENT NAME

DATE

PHONE

EMAIL

LOOK / OCCASION

SKIN

PRIMER

FOUNDATION

CONCEALER

POWDER

HIGHLIGHTER

CONTOUR

BLUSH

EYES

BROW BONE

LID

CREASE

UNDER EYE

EYELINER

MASCARA

BROW

LIPS

LIP LINER

LIPSTICK

GLOSS

NOTES / INSPIRATION

KEY PRODUCTS AND TOOLS

CLIENT NAME _____ **DATE** _____
PHONE _____
EMAIL _____
LOOK / OCCASION _____

SKIN

PRIMER _____

FOUNDATION _____

CONCEALER _____

POWDER _____

HIGHLIGHTER _____

CONTOUR _____

BLUSH _____

EYES

BROW BONE _____

LID _____

CREASE _____

UNDER EYE _____

EYELINER _____

MASCARA _____

BROW _____

LIPS

LIP LINER _____

LIPSTICK _____

GLOSS _____

--- KEY PRODUCTS AND TOOLS ---

--- NOTES / INSPIRATION ---

CLIENT NAME

DATE

PHONE

EMAIL

LOOK / OCCASION

SKIN

PRIMER

FOUNDATION

CONCEALER

POWDER

HIGHLIGHTER

CONTOUR

BLUSH

EYES

BROW BONE

LID

CREASE

UNDER EYE

EYELINER

MASCARA

BROW

LIPS

LIP LINER

LIPSTICK

GLOSS

NOTES / INSPIRATION

KEY PRODUCTS AND TOOLS

CLIENT NAME

DATE

PHONE

EMAIL

LOOK / OCCASION

SKIN

PRIMER

FOUNDATION

CONCEALER

POWDER

HIGHLIGHTER

CONTOUR

BLUSH

EYES

BROW BONE

LID

CREASE

UNDER EYE

EYELINER

MASCARA

BROW

LIPS

LIP LINER

LIPSTICK

GLOSS

NOTES / INSPIRATION

KEY PRODUCTS AND TOOLS

CLIENT NAME

DATE

PHONE

EMAIL

LOOK / OCCASION

SKIN

PRIMER

FOUNDATION

CONCEALER

POWDER

HIGHLIGHTER

CONTOUR

BLUSH

EYES

BROW BONE

LID

CREASE

UNDER EYE

EYELINER

MASCARA

BROW

LIPS

LIP LINER

LIPSTICK

GLOSS

KEY PRODUCTS AND TOOLS

NOTES / INSPIRATION

CLIENT NAME

DATE

PHONE

EMAIL

LOOK / OCCASION

SKIN

PRIMER

FOUNDATION

CONCEALER

POWDER

HIGHLIGHTER

CONTOUR

BLUSH

EYES

BROW BONE

LID

CREASE

UNDER EYE

EYELINER

MASCARA

BROW

LIPS

LIP LINER

LIPSTICK

GLOSS

KEY PRODUCTS AND TOOLS

NOTES / INSPIRATION

CLIENT NAME

DATE

PHONE

EMAIL

LOOK / OCCASION

SKIN

PRIMER

FOUNDATION

CONCEALER

POWDER

HIGHLIGHTER

CONTOUR

BLUSH

EYES

BROW BONE

LID

CREASE

UNDER EYE

EYELINER

MASCARA

BROW

LIPS

LIP LINER

LIPSTICK

GLOSS

KEY PRODUCTS AND TOOLS

NOTES / INSPIRATION

CLIENT NAME

DATE

PHONE

EMAIL

LOOK / OCCASION

SKIN

PRIMER

FOUNDATION

CONCEALER

POWDER

HIGHLIGHTER

CONTOUR

BLUSH

EYES

BROW BONE

LID

CREASE

UNDER EYE

EYELINER

MASCARA

BROW

LIPS

LIP LINER

LIPSTICK

GLOSS

NOTES / INSPIRATION

KEY PRODUCTS AND TOOLS

CLIENT NAME

DATE

PHONE

EMAIL

LOOK / OCCASION

SKIN

PRIMER

FOUNDATION

CONCEALER

POWDER

HIGHLIGHTER

CONTOUR

BLUSH

EYES

BROW BONE

LID

CREASE

UNDER EYE

EYELINER

MASCARA

BROW

LIPS

LIP LINER

LIPSTICK

GLOSS

NOTES / INSPIRATION

KEY PRODUCTS AND TOOLS

CLIENT NAME

DATE

PHONE

EMAIL

LOOK / OCCASION

SKIN

PRIMER

FOUNDATION

CONCEALER

POWDER

HIGHLIGHTER

CONTOUR

BLUSH

EYES

BROW BONE

LID

CREASE

UNDER EYE

EYELINER

MASCARA

BROW

LIPS

LIP LINER

LIPSTICK

GLOSS

KEY PRODUCTS AND TOOLS

NOTES / INSPIRATION

CLIENT NAME

DATE

PHONE

EMAIL

LOOK / OCCASION

SKIN

PRIMER

FOUNDATION

CONCEALER

POWDER

HIGHLIGHTER

CONTOUR

BLUSH

EYES

BROW BONE

LID

CREASE

UNDER EYE

EYELINER

MASCARA

BROW

LIPS

LIP LINER

LIPSTICK

GLOSS

KEY PRODUCTS AND TOOLS

NOTES / INSPIRATION

CLIENT NAME

DATE

PHONE

EMAIL

LOOK / OCCASION

SKIN

PRIMER

FOUNDATION

CONCEALER

POWDER

HIGHLIGHTER

CONTOUR

BLUSH

EYES

BROW BONE

LID

CREASE

UNDER EYE

EYELINER

MASCARA

BROW

LIPS

LIP LINER

LIPSTICK

GLOSS

KEY PRODUCTS AND TOOLS

NOTES / INSPIRATION

CLIENT NAME

DATE

PHONE

EMAIL

LOOK / OCCASION

SKIN

PRIMER

FOUNDATION

CONCEALER

POWDER

HIGHLIGHTER

CONTOUR

BLUSH

EYES

BROW BONE

LID

CREASE

UNDER EYE

EYELINER

MASCARA

BROW

LIPS

LIP LINER

LIPSTICK

GLOSS

KEY PRODUCTS AND TOOLS

NOTES / INSPIRATION

CLIENT NAME

DATE

PHONE

EMAIL

LOOK / OCCASION

SKIN

PRIMER

FOUNDATION

CONCEALER

POWDER

HIGHLIGHTER

CONTOUR

BLUSH

EYES

BROW BONE

LID

CREASE

UNDER EYE

EYELINER

MASCARA

BROW

LIPS

LIP LINER

LIPSTICK

GLOSS

KEY PRODUCTS AND TOOLS

NOTES / INSPIRATION

CLIENT NAME

DATE

PHONE

EMAIL

LOOK / OCCASION

SKIN

PRIMER

FOUNDATION

CONCEALER

POWDER

HIGHLIGHTER

CONTOUR

BLUSH

EYES

BROW BONE

LID

CREASE

UNDER EYE

EYELINER

MASCARA

BROW

LIPS

LIP LINER

LIPSTICK

GLOSS

KEY PRODUCTS AND TOOLS

NOTES / INSPIRATION

CLIENT NAME

DATE

PHONE

EMAIL

LOOK / OCCASION

SKIN

PRIMER

FOUNDATION

CONCEALER

POWDER

HIGHLIGHTER

CONTOUR

BLUSH

EYES

BROW BONE

LID

CREASE

UNDER EYE

EYELINER

MASCARA

BROW

LIPS

LIP LINER

LIPSTICK

GLOSS

KEY PRODUCTS AND TOOLS

NOTES / INSPIRATION

CLIENT NAME

DATE

PHONE

EMAIL

LOOK / OCCASION

SKIN

PRIMER

FOUNDATION

CONCEALER

POWDER

HIGHLIGHTER

CONTOUR

BLUSH

EYES

BROW BONE

LID

CREASE

UNDER EYE

EYELINER

MASCARA

BROW

LIPS

LIP LINER

LIPSTICK

GLOSS

KEY PRODUCTS AND TOOLS

NOTES / INSPIRATION

CLIENT NAME

DATE

PHONE

EMAIL

LOOK / OCCASION

SKIN

PRIMER

FOUNDATION

CONCEALER

POWDER

HIGHLIGHTER

CONTOUR

BLUSH

EYES

BROW BONE

LID

CREASE

UNDER EYE

EYELINER

MASCARA

BROW

LIPS

LIP LINER

LIPSTICK

GLOSS

KEY PRODUCTS AND TOOLS

NOTES / INSPIRATION

CLIENT NAME

DATE

PHONE

EMAIL

LOOK / OCCASION

SKIN

PRIMER

FOUNDATION

CONCEALER

POWDER

HIGHLIGHTER

CONTOUR

BLUSH

EYES

BROW BONE

LID

CREASE

UNDER EYE

EYELINER

MASCARA

BROW

LIPS

LIP LINER

LIPSTICK

GLOSS

--- KEY PRODUCTS AND TOOLS ---

--- NOTES / INSPIRATION ---

CLIENT NAME _____ DATE _____
PHONE _____
EMAIL _____
LOOK / OCCASION _____

SKIN

PRIMER _____

FOUNDATION _____

CONCEALER _____

POWDER _____

HIGHLIGHTER _____

CONTOUR _____

BLUSH _____

EYES

BROW BONE _____

LID _____

CREASE _____

UNDER EYE _____

EYELINER _____

MASCARA _____

BROW _____

LIPS

LIP LINER _____

LIPSTICK _____

GLOSS _____

NOTES / INSPIRATION

KEY PRODUCTS AND TOOLS

CLIENT NAME

DATE

PHONE

EMAIL

LOOK / OCCASION

SKIN

PRIMER

FOUNDATION

CONCEALER

POWDER

HIGHLIGHTER

CONTOUR

BLUSH

EYES

BROW BONE

LID

CREASE

UNDER EYE

EYELINER

MASCARA

BROW

LIPS

LIP LINER

LIPSTICK

GLOSS

NOTES / INSPIRATION

KEY PRODUCTS AND TOOLS

CLIENT NAME

DATE

PHONE

EMAIL

LOOK / OCCASION

SKIN

PRIMER

FOUNDATION

CONCEALER

POWDER

HIGHLIGHTER

CONTOUR

BLUSH

EYES

BROW BONE

LID

CREASE

UNDER EYE

EYELINER

MASCARA

BROW

LIPS

LIP LINER

LIPSTICK

GLOSS

KEY PRODUCTS AND TOOLS

NOTES / INSPIRATION

CLIENT NAME

DATE

PHONE

EMAIL

LOOK / OCCASION

SKIN

PRIMER

FOUNDATION

CONCEALER

POWDER

HIGHLIGHTER

CONTOUR

BLUSH

EYES

BROW BONE

LID

CREASE

UNDER EYE

EYELINER

MASCARA

BROW

LIPS

LIP LINER

LIPSTICK

GLOSS

KEY PRODUCTS AND TOOLS

NOTES / INSPIRATION

CLIENT NAME

DATE

PHONE

EMAIL

LOOK / OCCASION

SKIN

PRIMER

FOUNDATION

CONCEALER

POWDER

HIGHLIGHTER

CONTOUR

BLUSH

EYES

BROW BONE

LID

CREASE

UNDER EYE

EYELINER

MASCARA

BROW

LIPS

LIP LINER

LIPSTICK

GLOSS

KEY PRODUCTS AND TOOLS

NOTES / INSPIRATION

CLIENT NAME

DATE

PHONE

EMAIL

LOOK / OCCASION

SKIN

PRIMER

FOUNDATION

CONCEALER

POWDER

HIGHLIGHTER

CONTOUR

BLUSH

EYES

BROW BONE

LID

CREASE

UNDER EYE

EYELINER

MASCARA

BROW

LIPS

LIP LINER

LIPSTICK

GLOSS

NOTES / INSPIRATION

KEY PRODUCTS AND TOOLS

CLIENT NAME

DATE

PHONE

EMAIL

LOOK / OCCASION

SKIN

PRIMER

FOUNDATION

CONCEALER

POWDER

HIGHLIGHTER

CONTOUR

BLUSH

EYES

BROW BONE

LID

CREASE

UNDER EYE

EYELINER

MASCARA

BROW

LIPS

LIP LINER

LIPSTICK

GLOSS

KEY PRODUCTS AND TOOLS

NOTES / INSPIRATION

CLIENT NAME

DATE

PHONE

EMAIL

LOOK / OCCASION

SKIN

PRIMER

FOUNDATION

CONCEALER

POWDER

HIGHLIGHTER

CONTOUR

BLUSH

EYES

BROW BONE

LID

CREASE

UNDER EYE

EYELINER

MASCARA

BROW

LIPS

LIP LINER

LIPSTICK

GLOSS

KEY PRODUCTS AND TOOLS

NOTES / INSPIRATION

CLIENT NAME _____ **DATE** _____
PHONE _____
EMAIL _____
LOOK / OCCASION _____

SKIN

PRIMER _____

FOUNDATION _____

CONCEALER _____

POWDER _____

HIGHLIGHTER _____

CONTOUR _____

BLUSH _____

EYES

BROW BONE _____

LID _____

CREASE _____

UNDER EYE _____

EYELINER _____

MASCARA _____

BROW _____

LIPS

LIP LINER _____

LIPSTICK _____

GLOSS _____

KEY PRODUCTS AND TOOLS

NOTES / INSPIRATION

Thank you for getting Our Book

First of all, We would like to thank you for purchasing this book. We are extremally grateful.

We hope that it added value and quality to your everyday life.

If so, it would be really nice if you could share this book with your friends and family by posting to Facebook Twitter, and social media.

If you enjoy using it and found some benefit in reading this, we would appreciate your review on Amazon. Just head on over to this book's Amazon page and click " Write a customer review". We read each and every one of them.

Your feedback and support will help this author to greatly improve his writing craft for future projects and make this book even better.

We wish you all the best in your future!

Copyright © 2020 by Arrow Print

All rights reserved. No part of this publication may be reproduced, distributed, or transmitted in any form or by any means, including photocopying, recording, or other electronic or mechanical methods, without the prior written permission of the publisher, except in case of brief quotation embodied in critical reviews and certain other noncommercial uses permitted by copyright law.

notebookspace.com

Made in the USA
Columbia, SC
18 May 2024

35856871R00070